Quotable Mothers

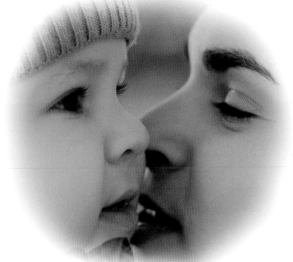

Milly Brown

summersdale

QUOTABLE MOTHERS

Summersdale Publishers Ltd
46 West Street
Chichester
West Sussex
PO19 1RP
UK

www.summersdale.com

Printed and bound by Tien Wah Press, Singapore

All images © Shutterstock

ISBN: 1-84024-623-5

ISBN 13: 978-1-84024-623-0

Quotable Mothers

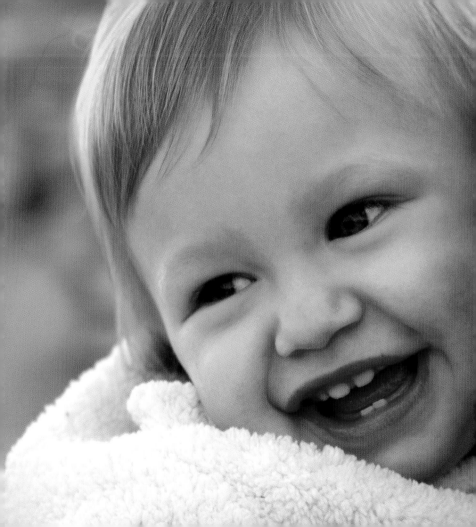

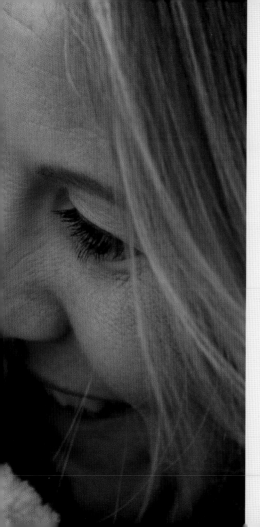

To a child's ear,
'mother' is
magic in any
language.

Arlene Benedict

Our **mothers** always remain the strangest, **craziest people** we've ever met.

Marguerite Duras

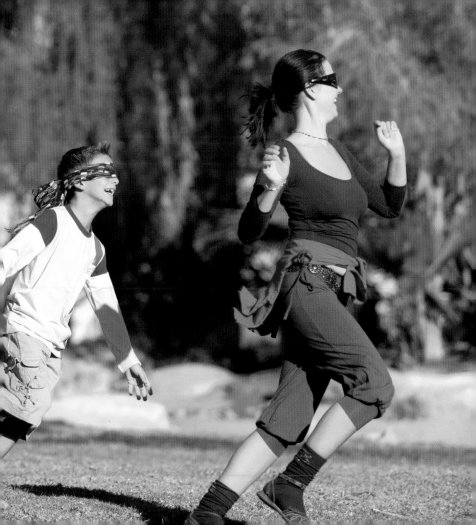

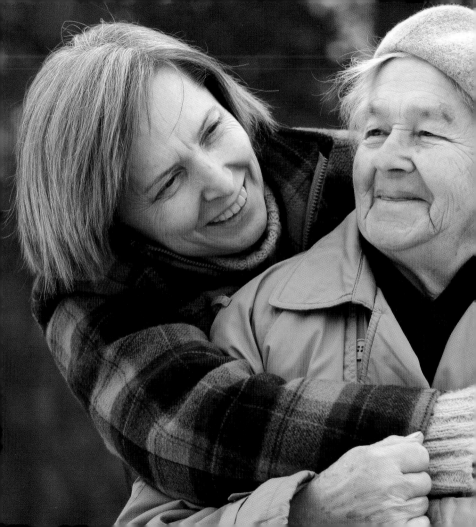

A mother's **happiness** is like a beacon, lighting up the **future** but reflected also on the past in the guise of **fond memories**.

Honoré de Balzac

Making the decision to have a child – **it's momentous**. It is to decide **forever** to have your **heart** go walking around outside your body.

Elizabeth Stone

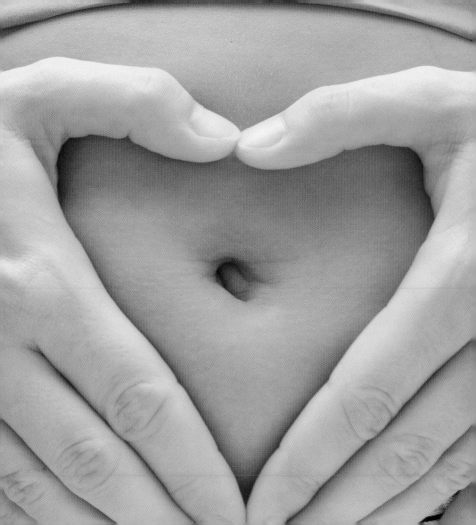

The Miracle of Life **nurtured** by a woman who gave us love and **sacrifice**... mother.

Joel Barquez

Mothers always **know**.

Oprah Winfrey

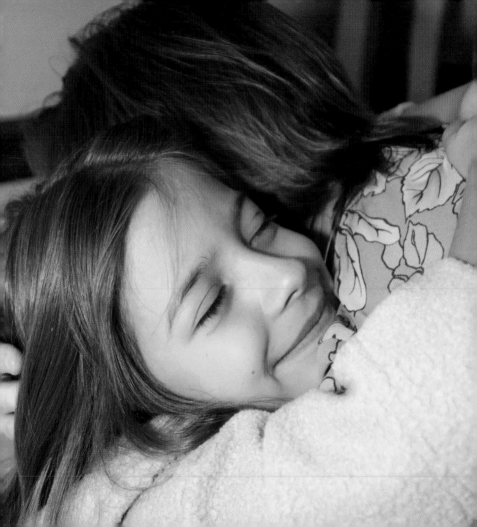

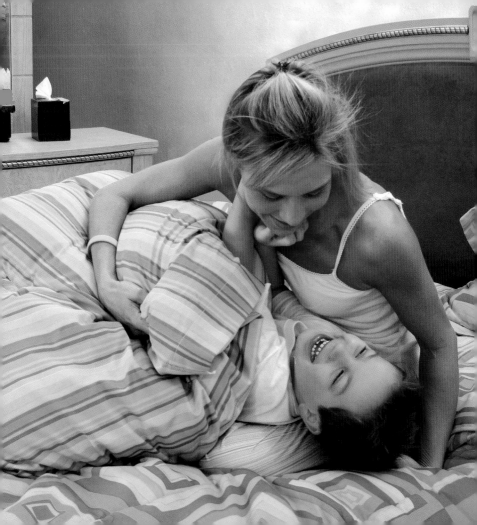

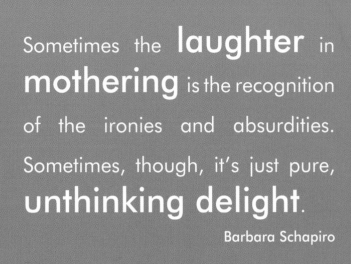

Sometimes the **laughter** in **mothering** is the recognition of the ironies and absurdities. Sometimes, though, it's just pure, **unthinking delight**.

Barbara Schapiro

My mother made a **brilliant** impression upon my **childhood** life. She shone for me like the **evening star**.

Winston Churchill

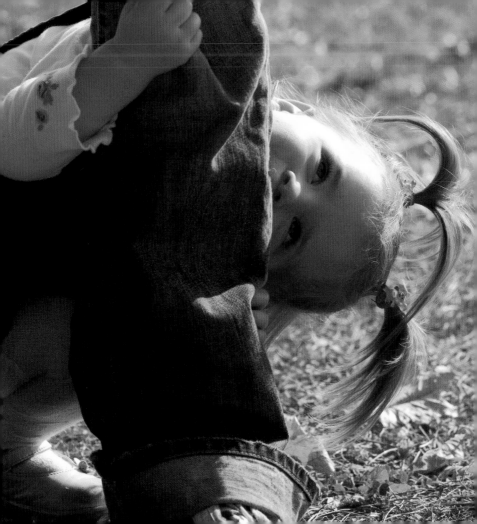

Heaven is at the feet of mothers.

Arabic proverb

Begin, **baby boy**, to recognise your **mother** with a smile.

Virgil

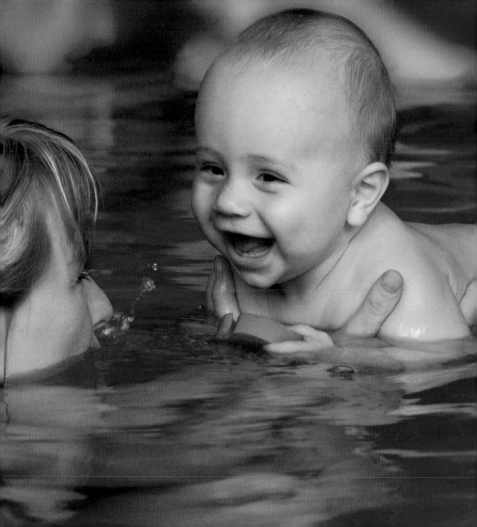

Stories first heard at a mother's knee are **never** wholly **forgotten**.

Giovanni Ruffini

She was **the best** of
all mothers, to whom I owe
endless **gratitude**.

Of all the **rights** of women, the **greatest** is to be a **mother**.

Lin Yutang

No language can express the **power** and **beauty** and **heroism** of a mother's love.

Edwin H. Chapin

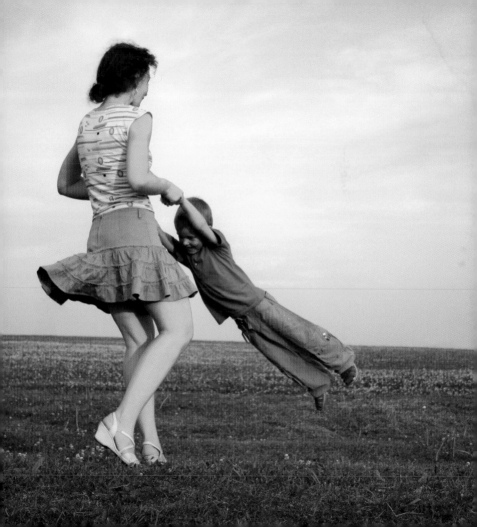

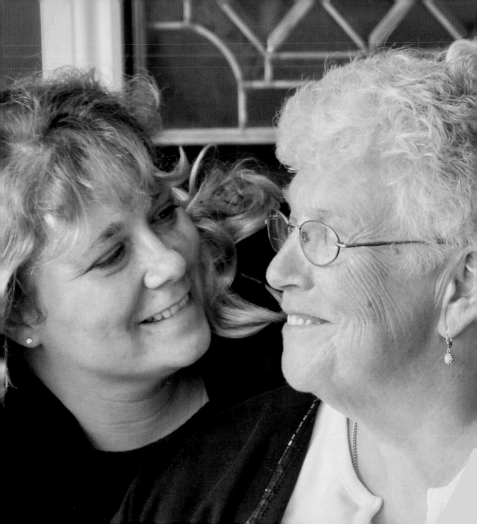

When your mother asks, 'Do you want a piece of **advice**?' it is a mere formality... You're going to get it **anyway**.

Erma Bombeck

A mother's **heart** is always with her **children.**

Proverb

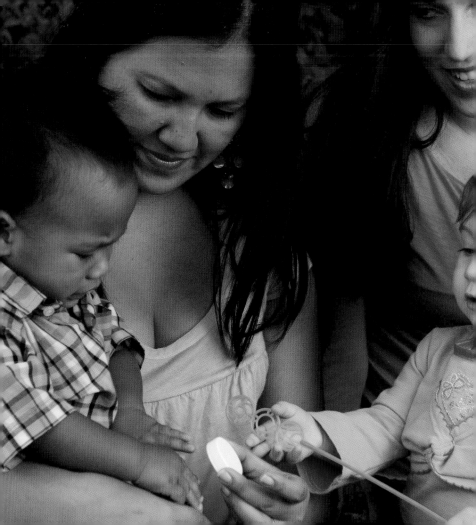

There is no way to be a **perfect**

mother, and a million ways to be a

good one.

Jill Churchill

A mother is not a **person** to lean on but a person to make **leaning unnecessary**.

Dorothy Canfield Fisher

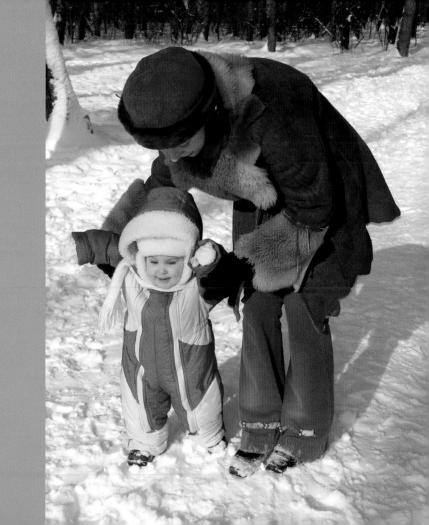

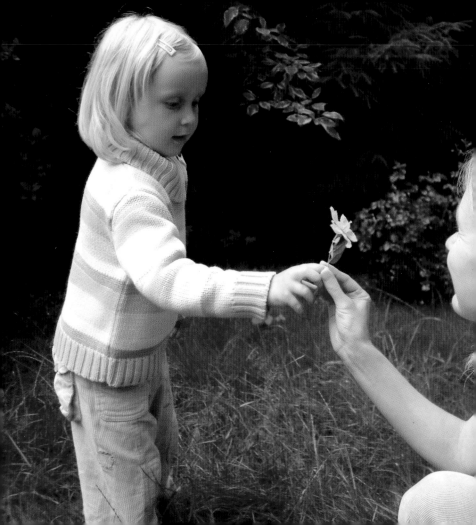

A mother **understands**

what a **child** does not say.

Anonymous

A mother's **love** perceives no **impossibilities**.

Cornelia Paddock

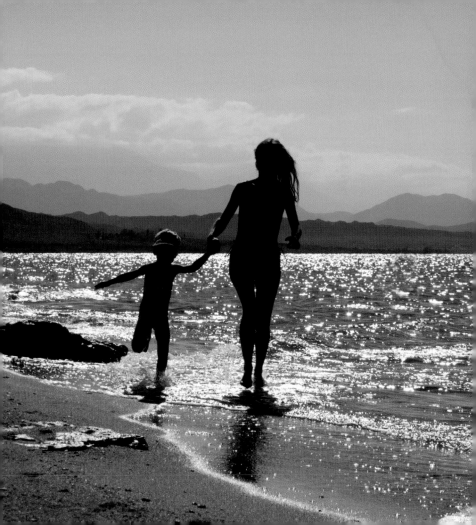

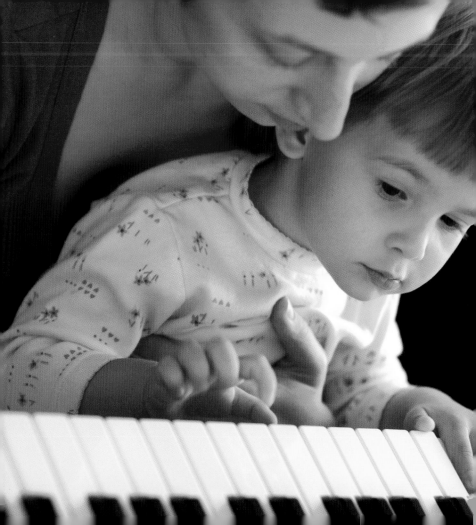

That **best academy**, a mother's knee.

James Russell Lowell

Motherhood: all **love**
begins and ends there.

Robert Browning

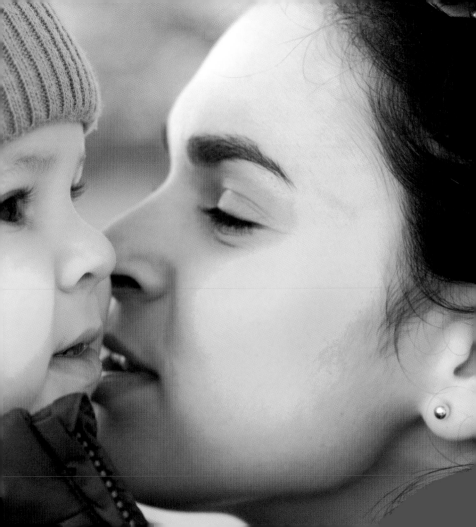

All motherly **love** is really without **reason** and **logic**.

Joan Chen

Good mothers know that their **relationship** with each of their **children** is like a movable feast, **constantly changing** and evolving.

Sue Woodman

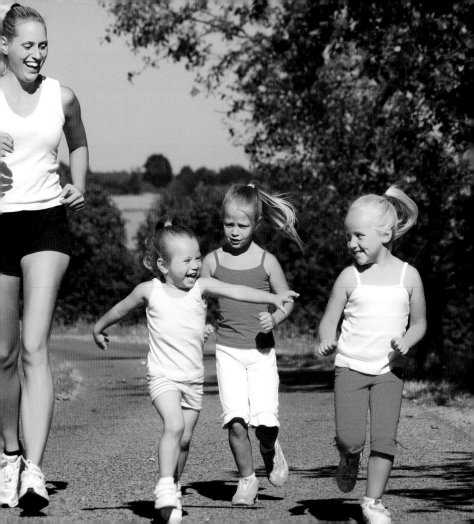

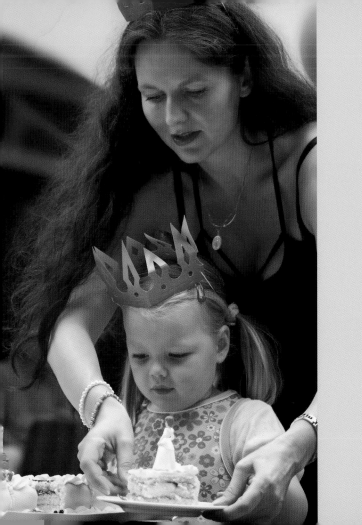

Anyone who doesn't **miss** the **past** never had a **mother**.

Gregory Nunn

I shall **never forget** my mother, for it was she who **planted** and **nurtured** the first seeds of good within me.

Immanuel Kant

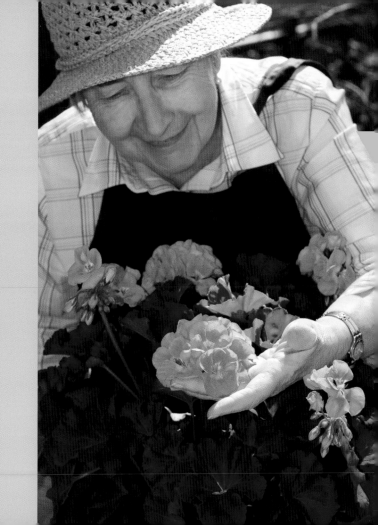

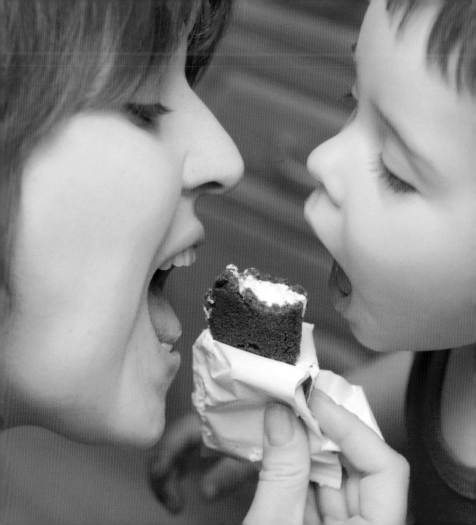

Mother's **love** grows by **giving**.

Charles Lamb

A man's work is from sun to sun, but a mother's **work** is **never done**.

Anonymous

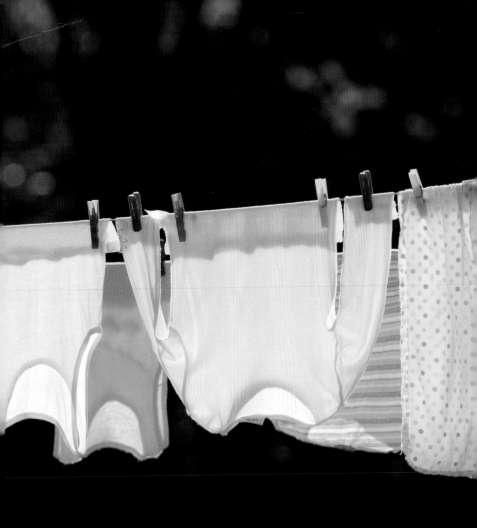

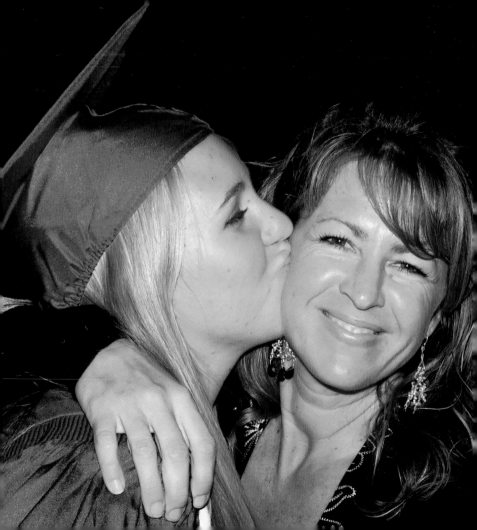

All that I am my mother made me.

John Quincy Adams

Mother: the most **beautiful** word on the lips of **mankind**.

Kahlil Gibran

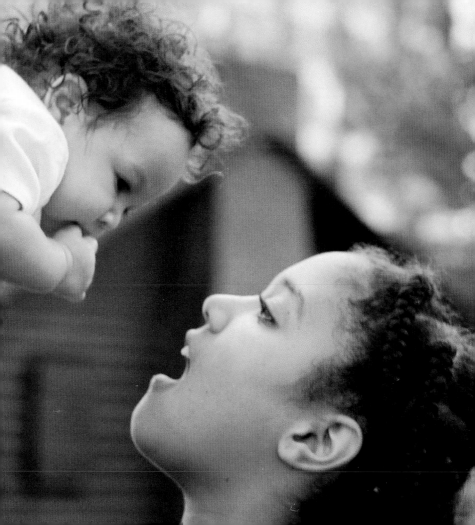

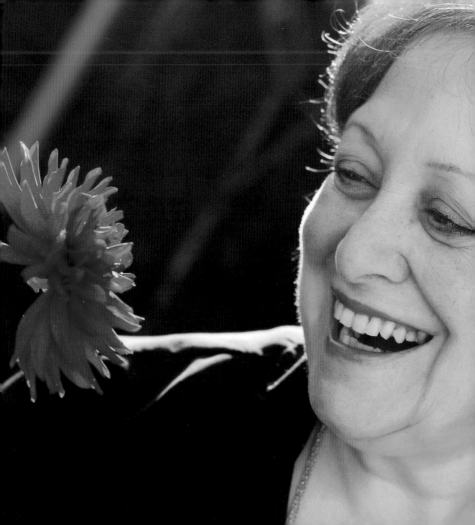

Beautiful as was mamma's **face**, it became incomparably more **lovely** when she smiled, and seemed to **enliven** everything about her.

Leo Tolstoy

Mothers are the people who love us for **no good reason**. And those of us who are mothers know it's the most **exquisite love** of all.

Maggie Gallagher

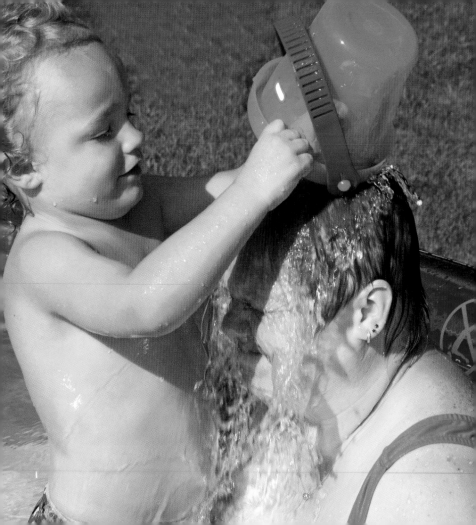

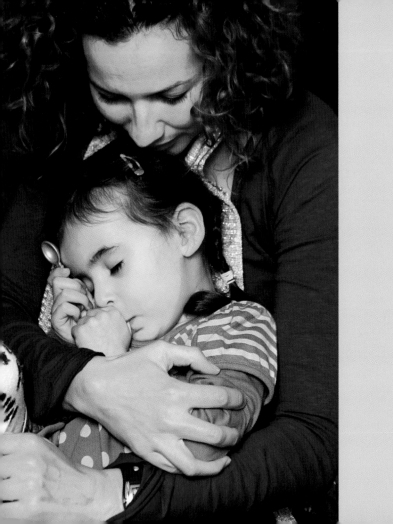

A **mother's arms** are made of tenderness and children **sleep soundly** in them.

Victor Hugo

All mothers are **rich** when they love their children. There are no **poor** mothers, no ugly ones, no old ones. Their love is always the most **beautiful** of joys.

Maurice Maeterlinck

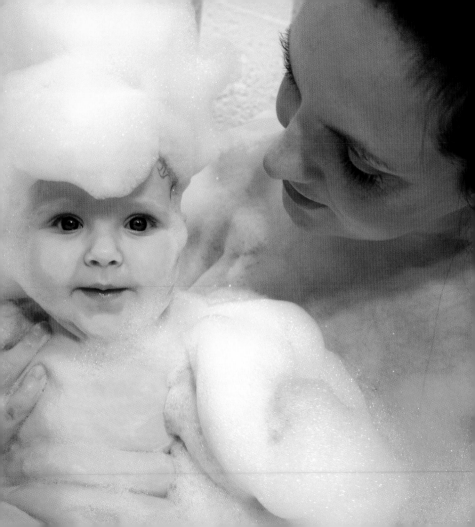

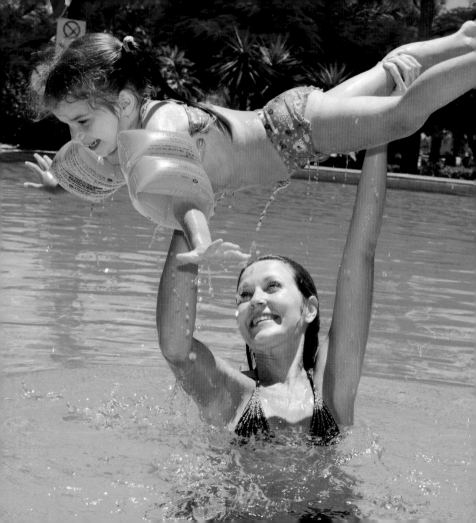

Like **kites** without strings, and **butterflies** without wings, my mother taught me to soar with my **dreams**.

William H. McMurry III

Youth fades; love droops; the leaves of friendship fall; a mother's secret hope outlives them all.

Oliver Wendell Holmes

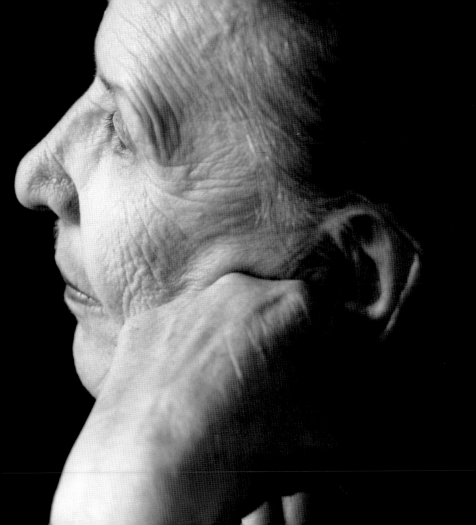

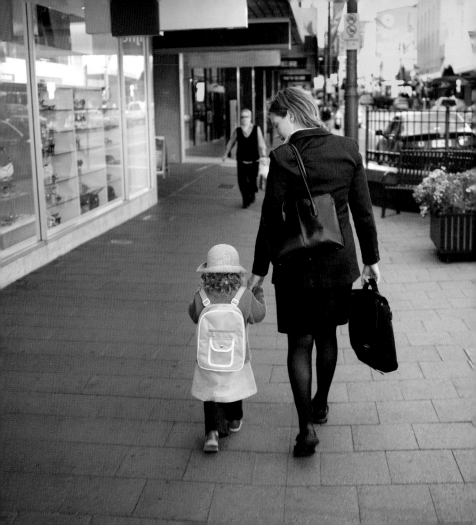

A mother is she who can **take the place** of all others but whose place **no one else** can take.

Cardinal Mermillod

A mother's **love** for her child is like nothing else in the **world**.

Agatha Christie

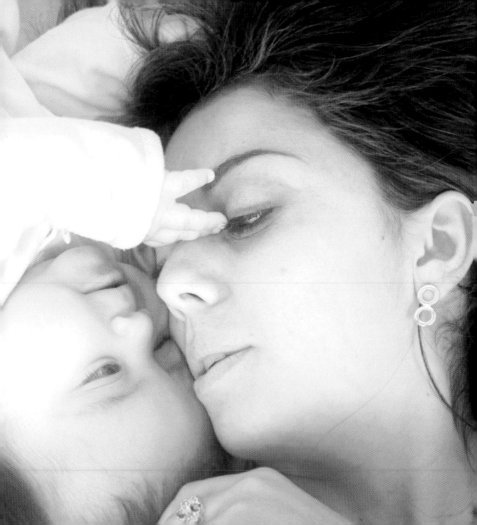

A little girl, asked where **her home** was, replied, '**Where mother is.**'

Keith L. Brooks

A mother's **love** is something we keep locked **deep** in our **hearts**, always knowing it will be there to **comfort** us.

Harmony Ferrario

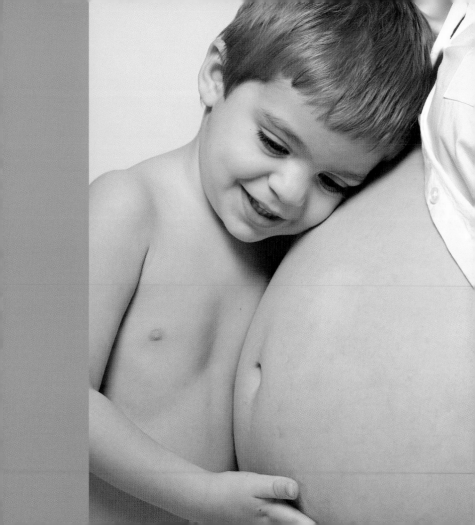

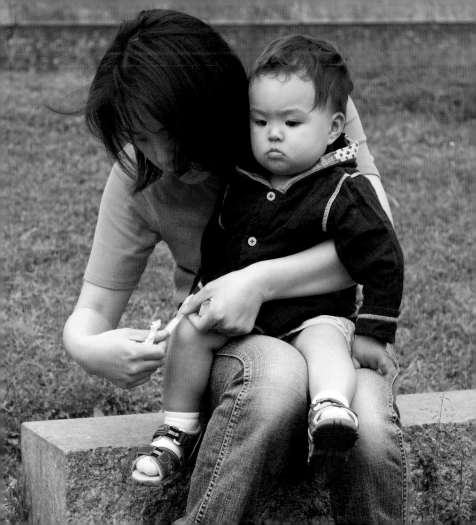

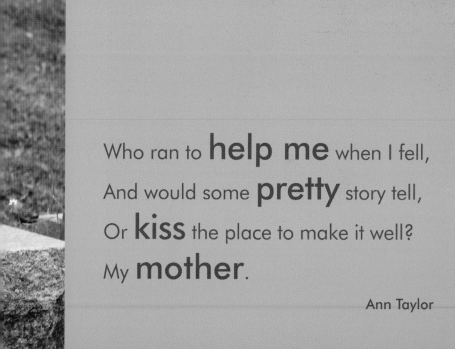

Who ran to **help me** when I fell,
And would some **pretty** story tell,
Or **kiss** the place to make it well?
My **mother**.

Ann Taylor

All mothers are quintessential: in pain and **joy** they are always with us, **encouraging**, instructing, **loving**.

Peter Megargee Brown

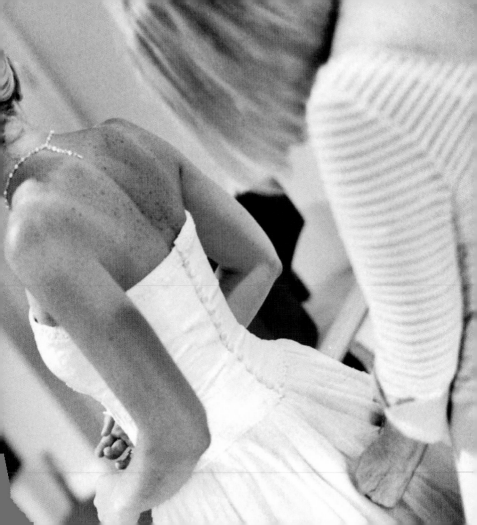

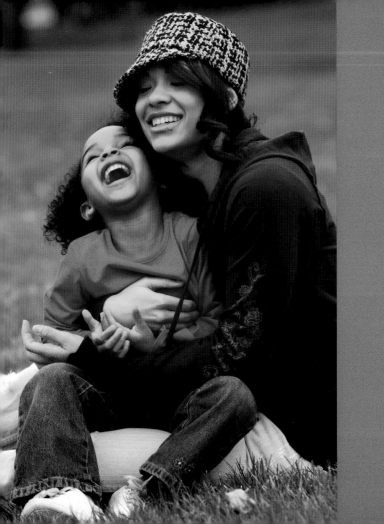

There is no **velvet** so soft as a mother's lap, no **rose** as lovely as her **smile**, no path so **flowery** as that imprinted with her **footsteps**.

Archibald Thompson

Mother's **love is peace**. It need not be acquired, it need not be **deserved**.

Erich Fromm

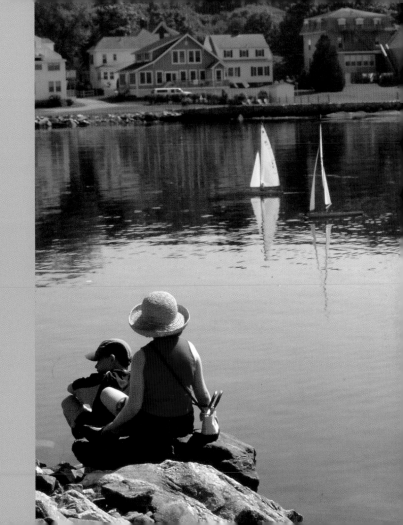

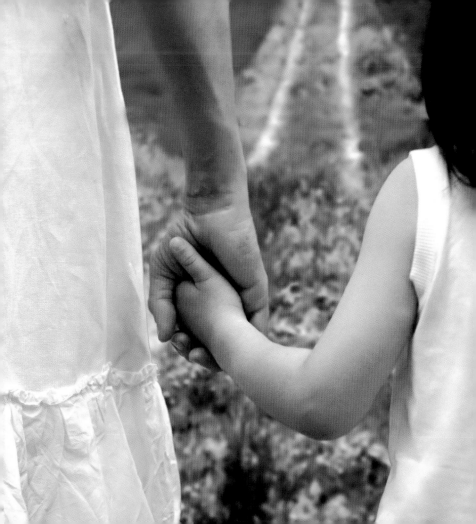

A mother holds her children's **hands** for a while, their hearts **forever**.

Anonymous

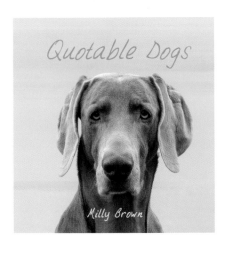

Quotable Dogs

Milly Brown

Hardback

£5.99

ISBN 13: 978 84024 537 0

No matter how little money and how few possessions you own, having a dog makes you rich.

Louis Sabin

A stunning photographic book with quotes about canines, this delightful celebration of your best friend and loyal companion is a pooch of a gift for every dog-lover.

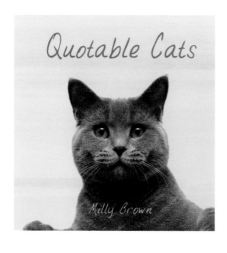

Quotable Cats

Milly Brown

Hardback

£5.99

ISBN 13: 978 84024 536 3

Thousands of years ago, cats were worshipped as gods. Cats have never forgotten this.

Anonymous

A beautiful photographic book with quotes about cats, this delightful celebration of the world's favourite furry friend is the purrfect gift for every cat-lover.

www.summersdale.com